COLORAMA™
INSPIRATION
Angels, Animals, Nature & More

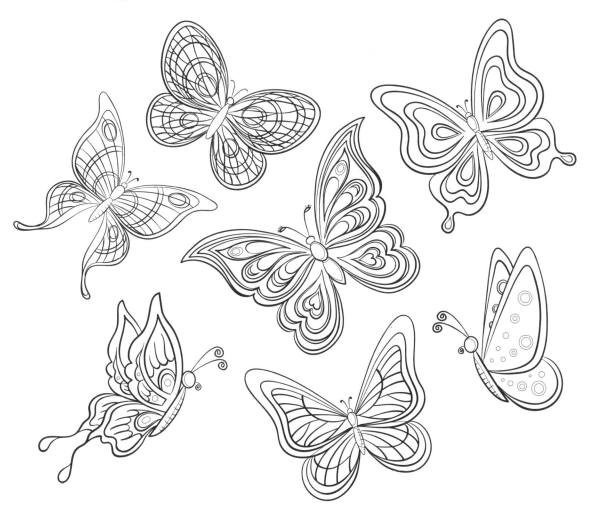

TELEBrands **PRESS**

To ensure the finest quality of your finished artwork,
we recommend placing a blank piece of paper
between the page you are coloring and the next page.

© 2015 Telebrands Press

This 2015 edition published by Telebrands Press
by arrangement with Castle Point Publishing

Telebrands Press
79 Two Bridges Road
Fairfield, NJ 07004

ISBN: 978-0-9909635-6-1

Printed in the U.S.A.
10 9 8 7 6 5 4 3 2 1

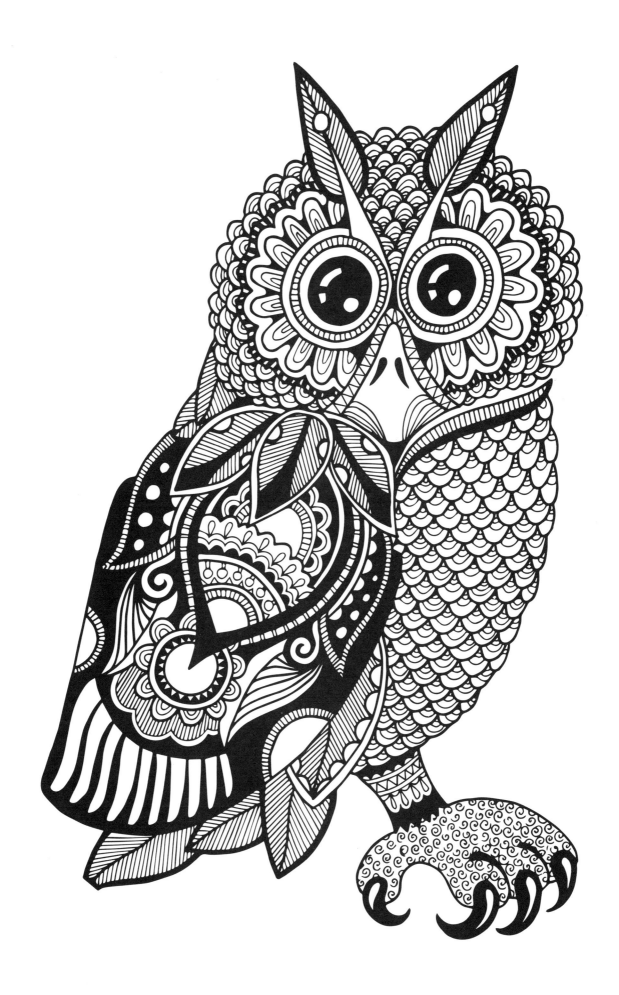

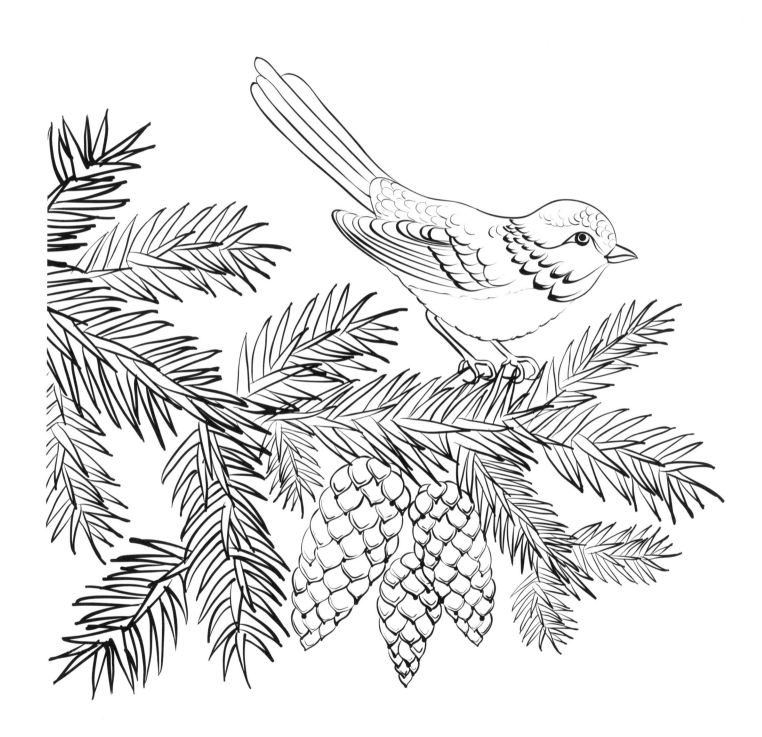

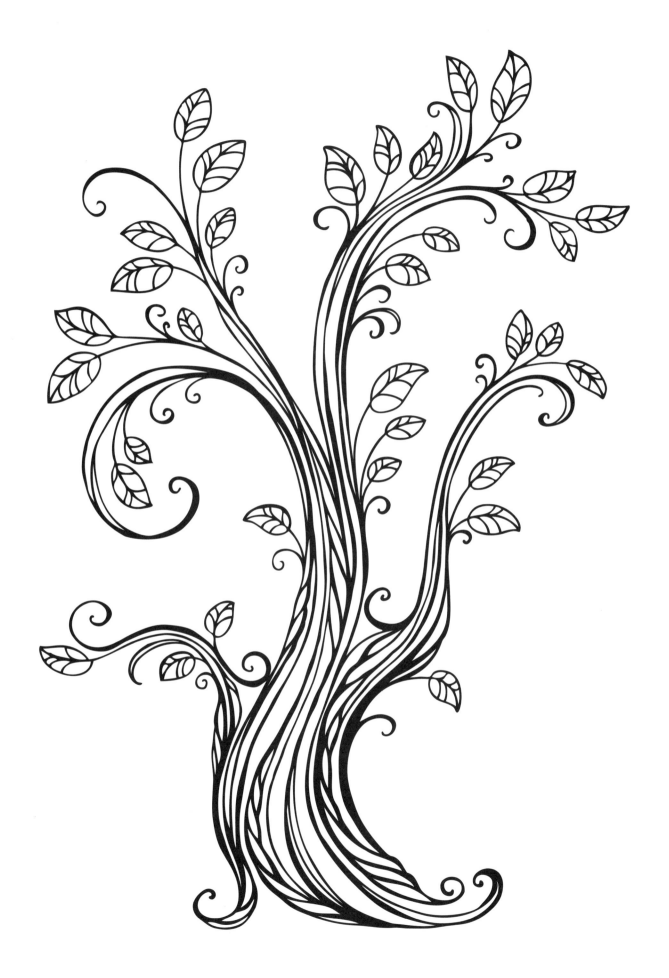

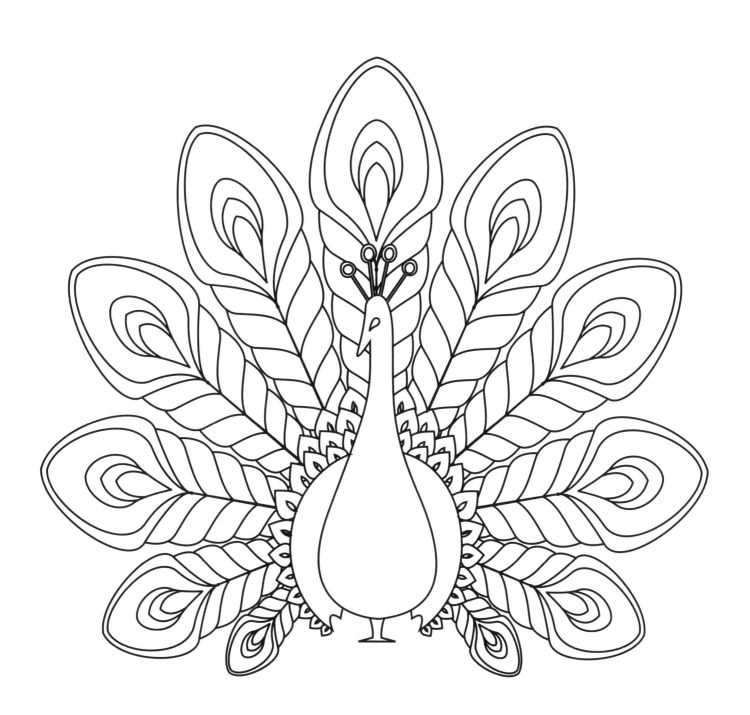

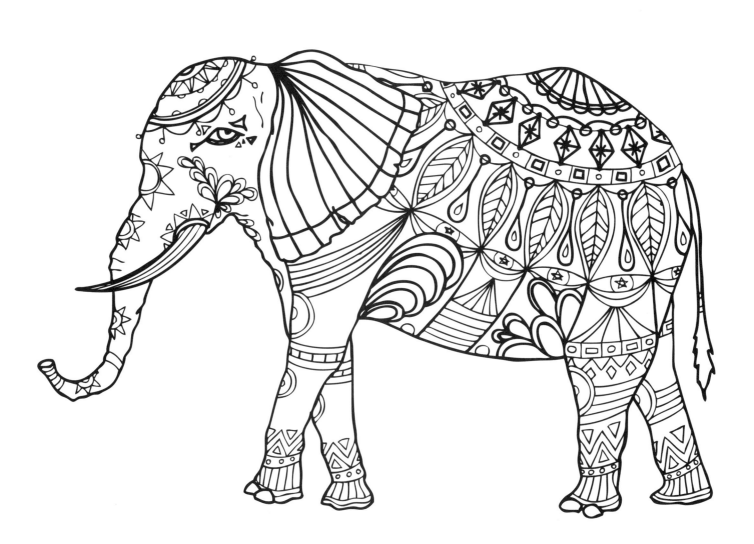

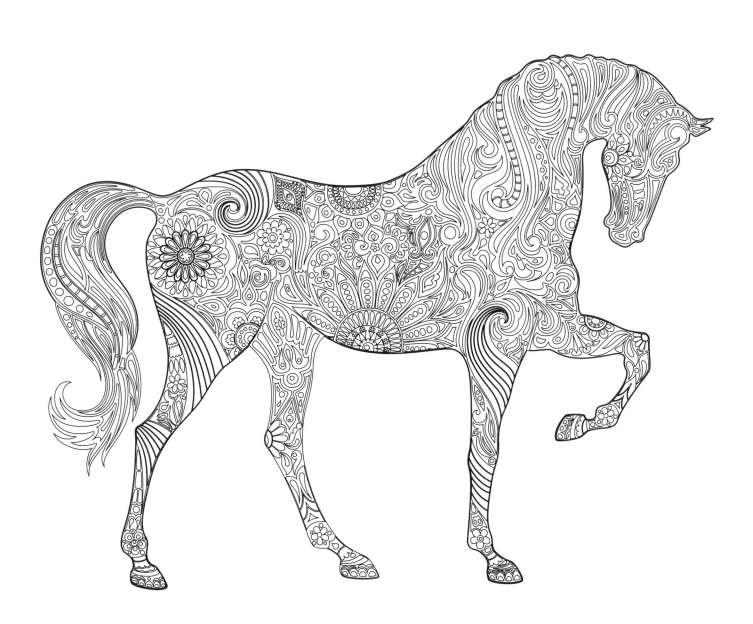

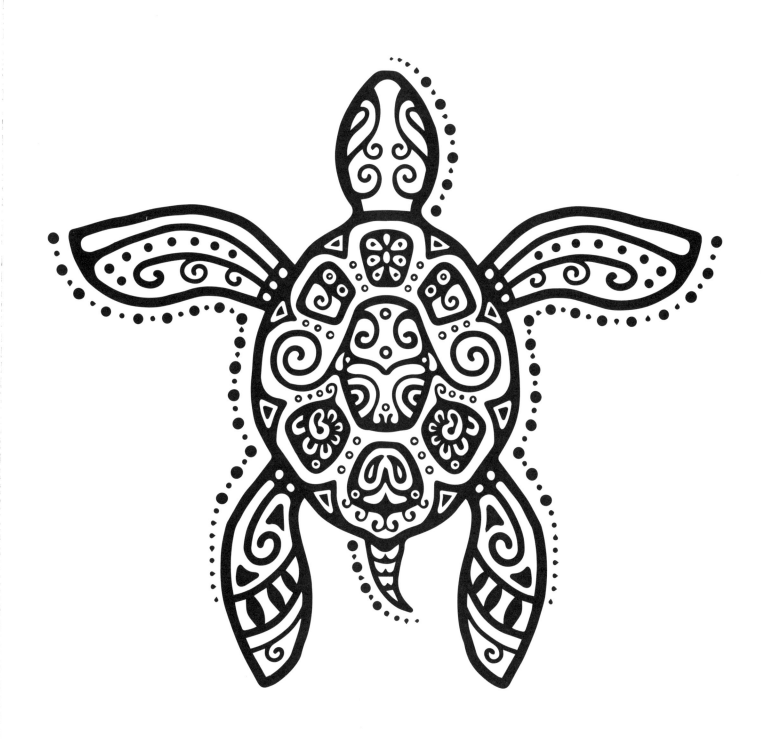

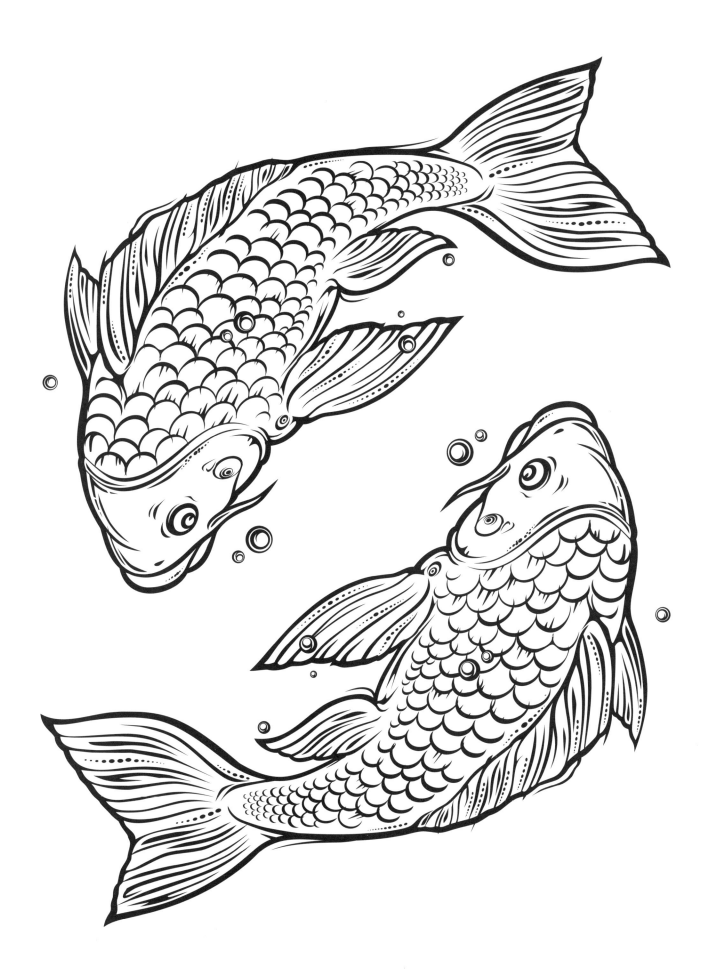

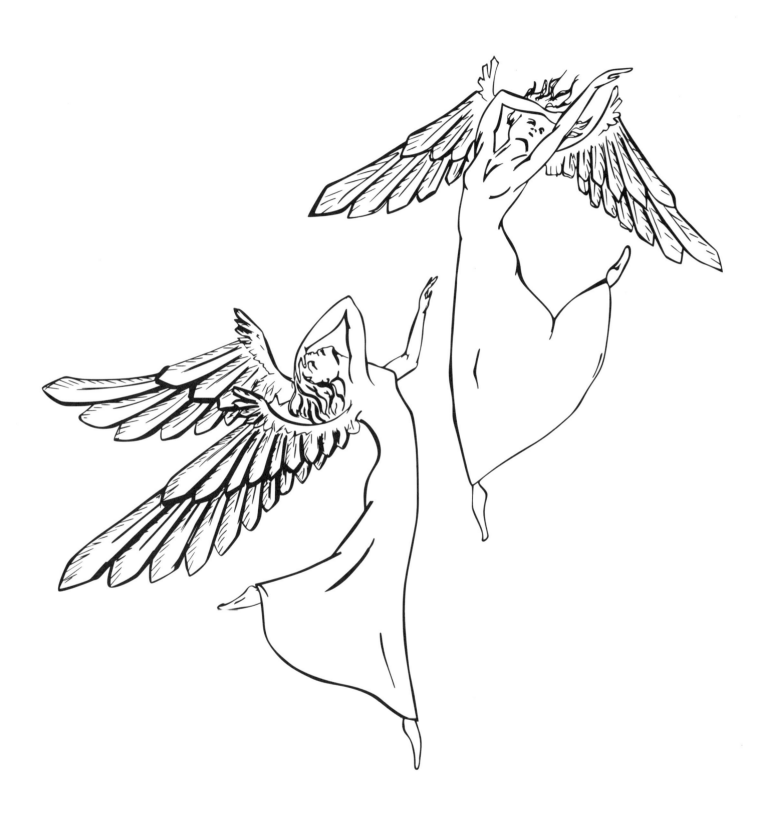

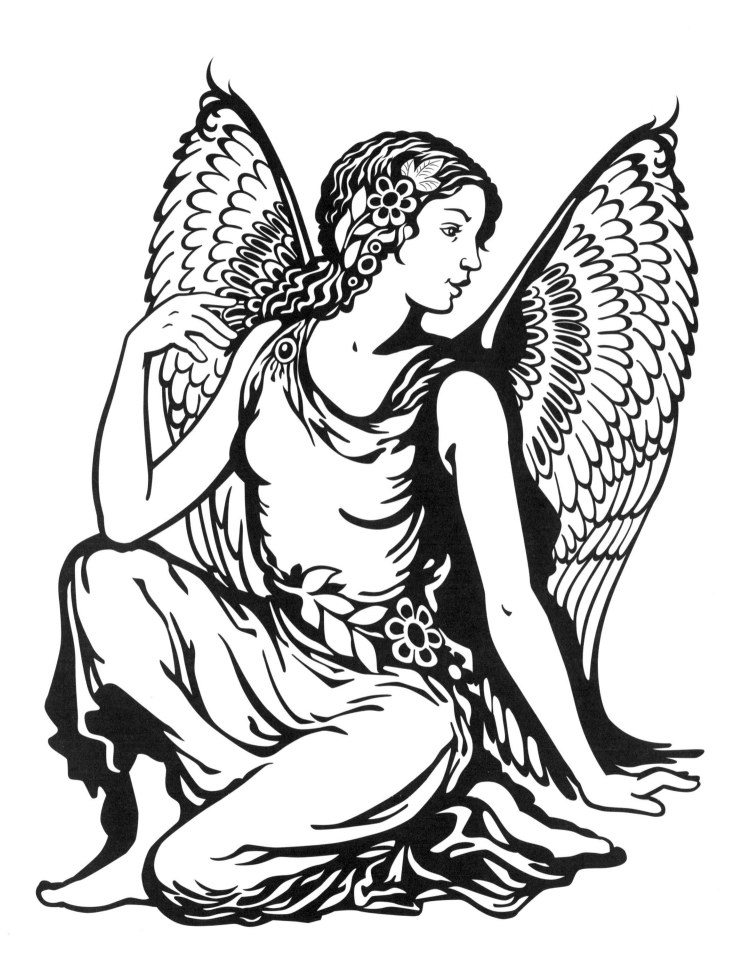

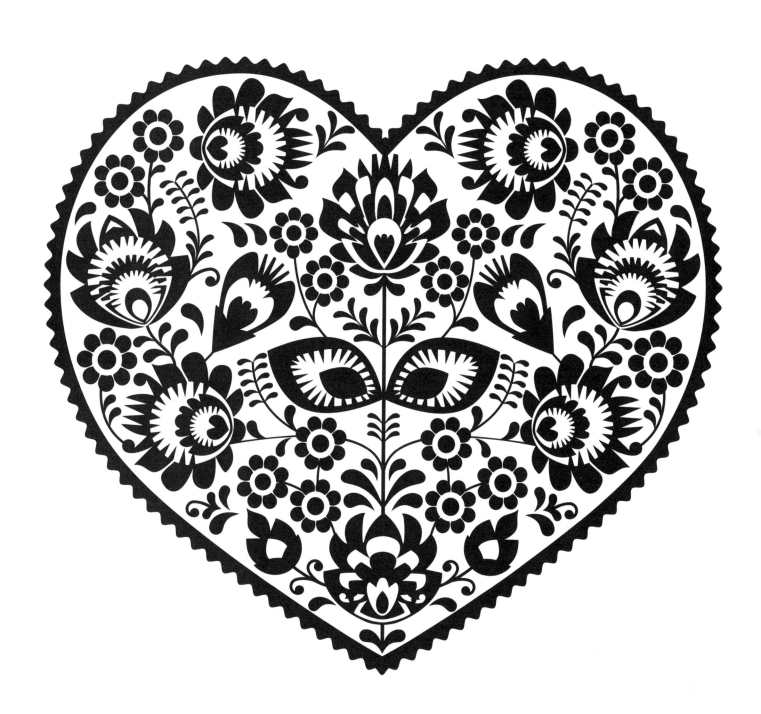

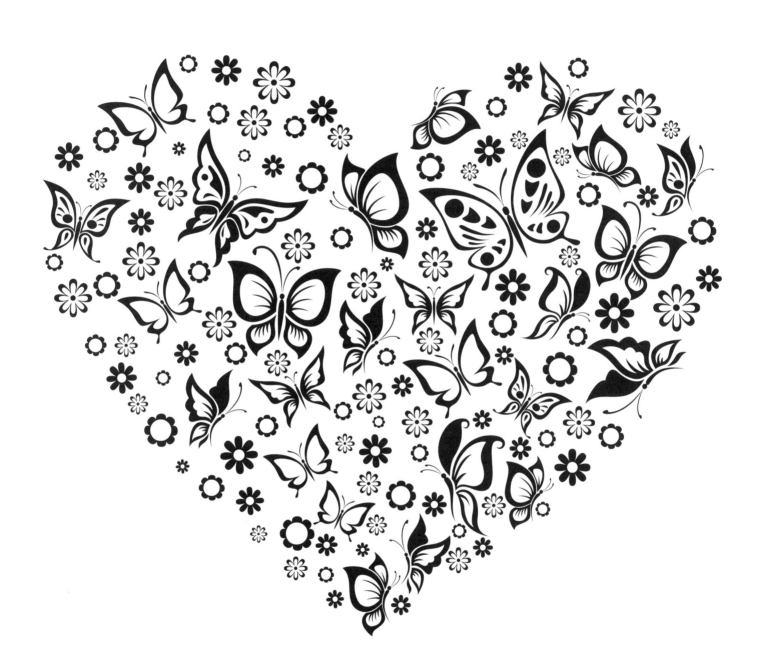

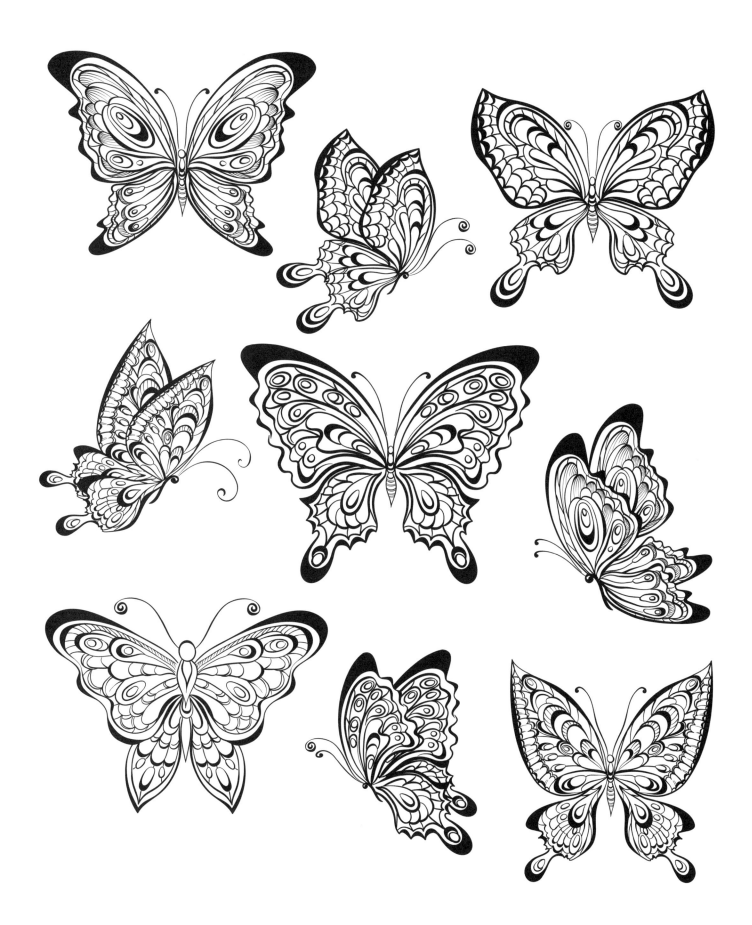

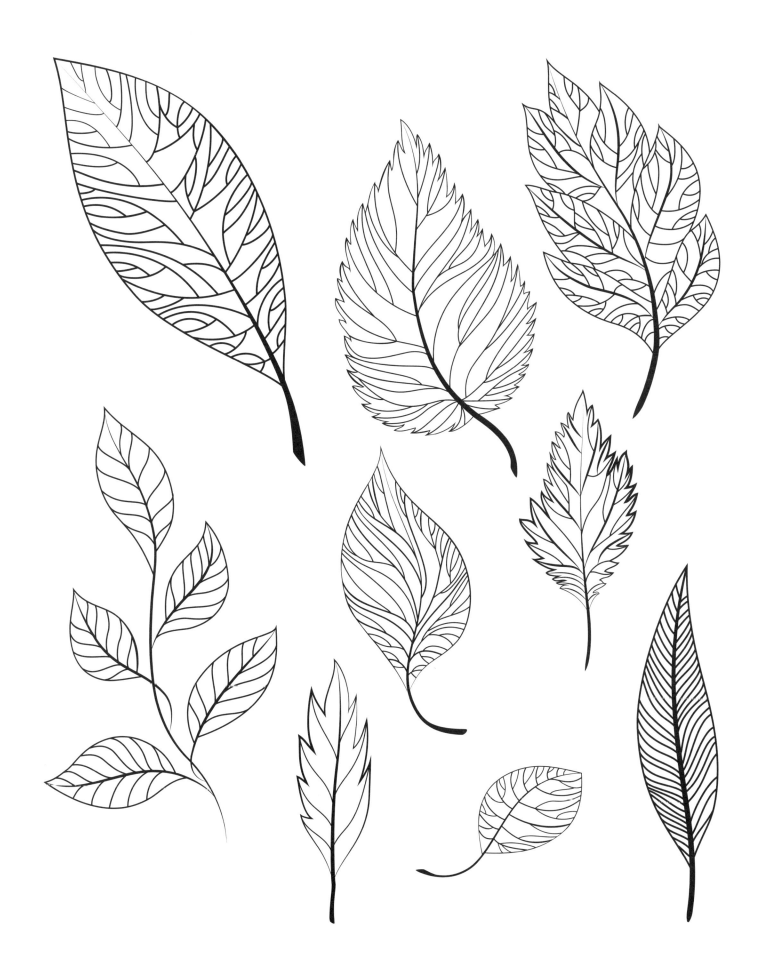

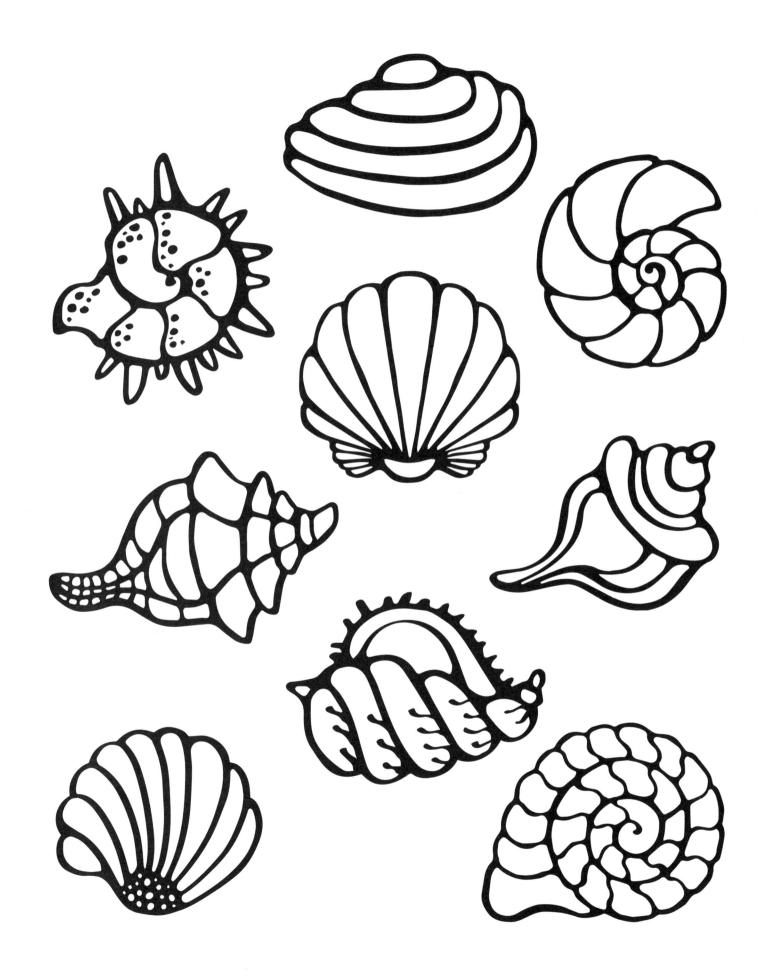

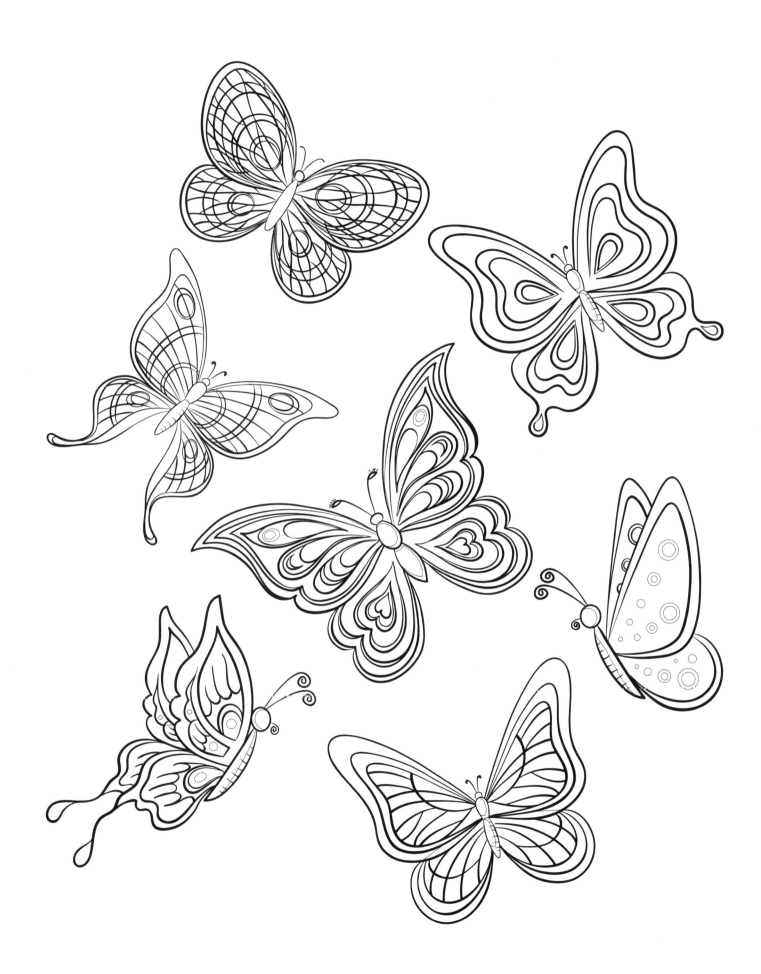

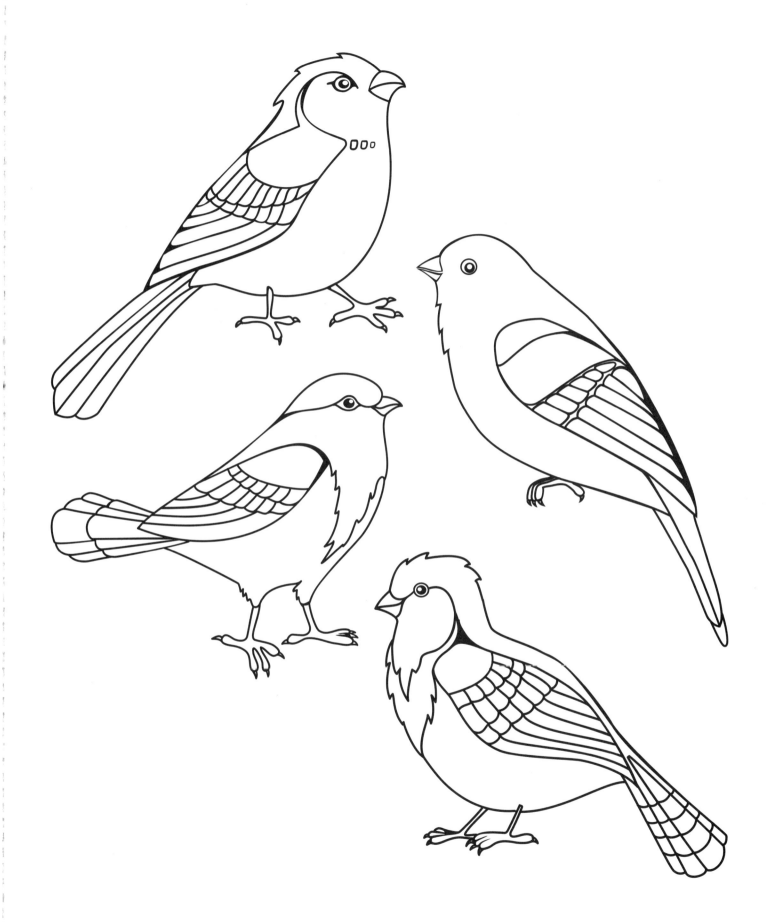

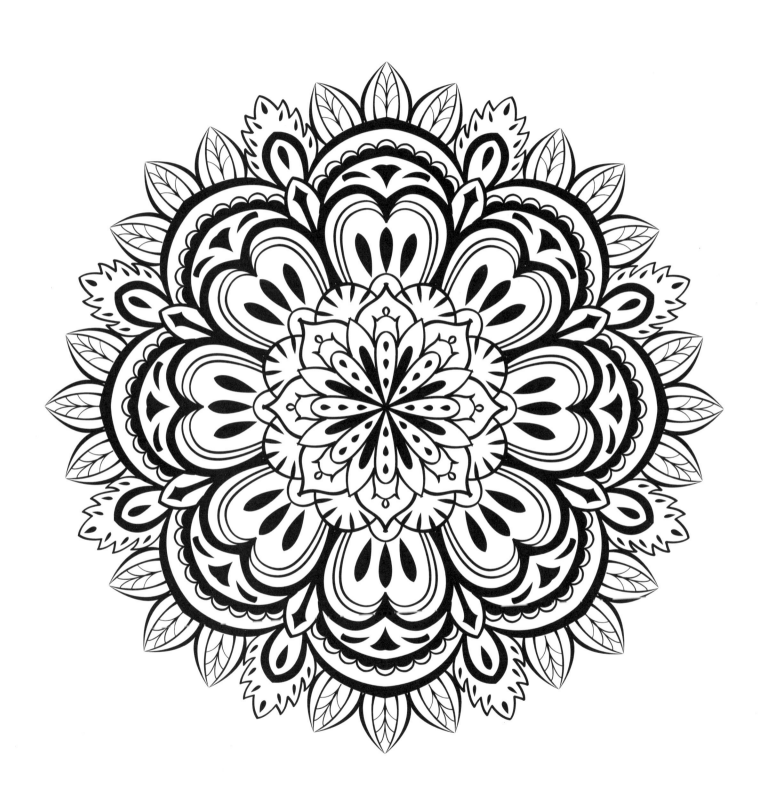

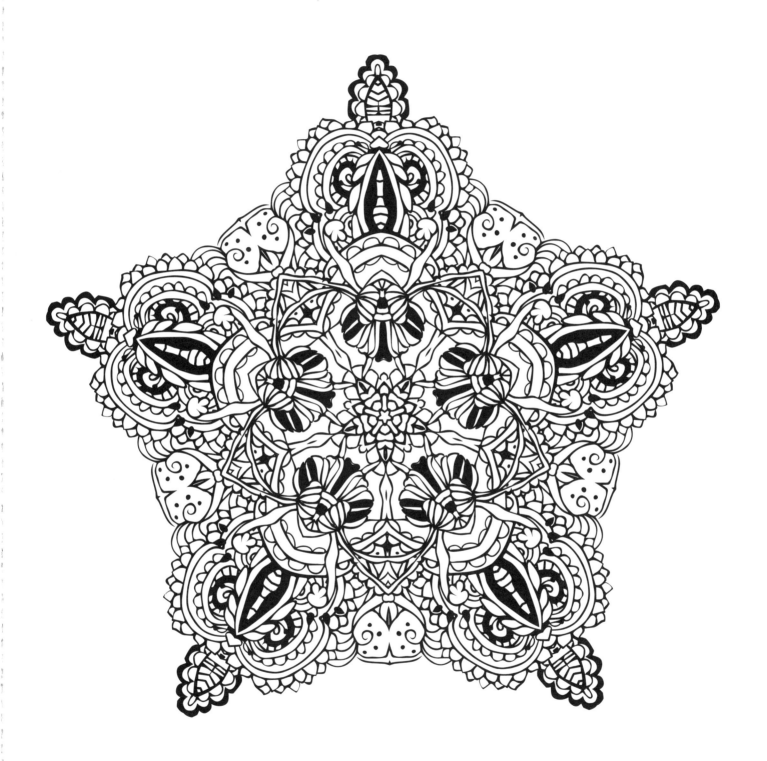

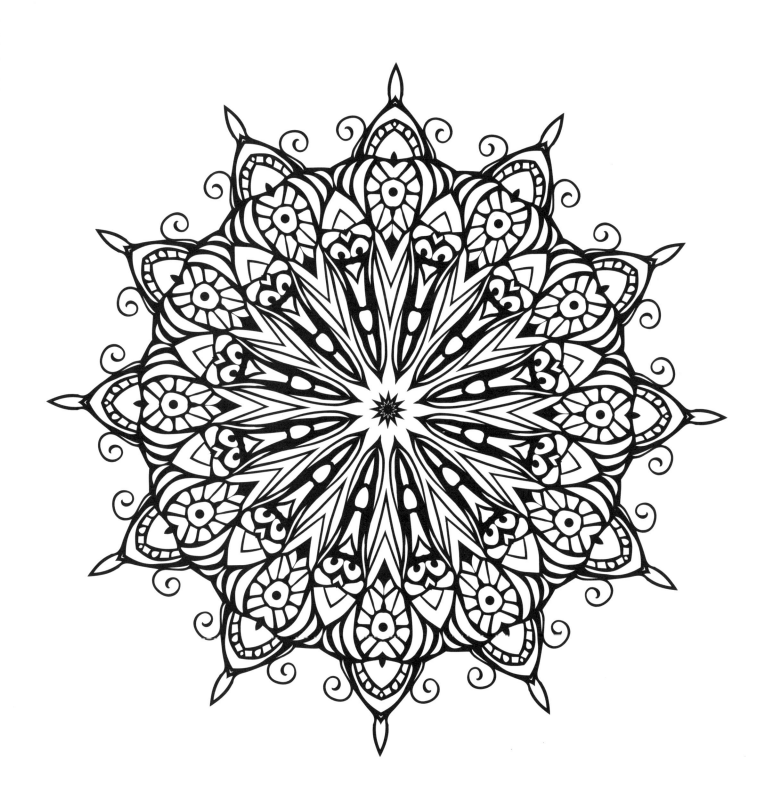

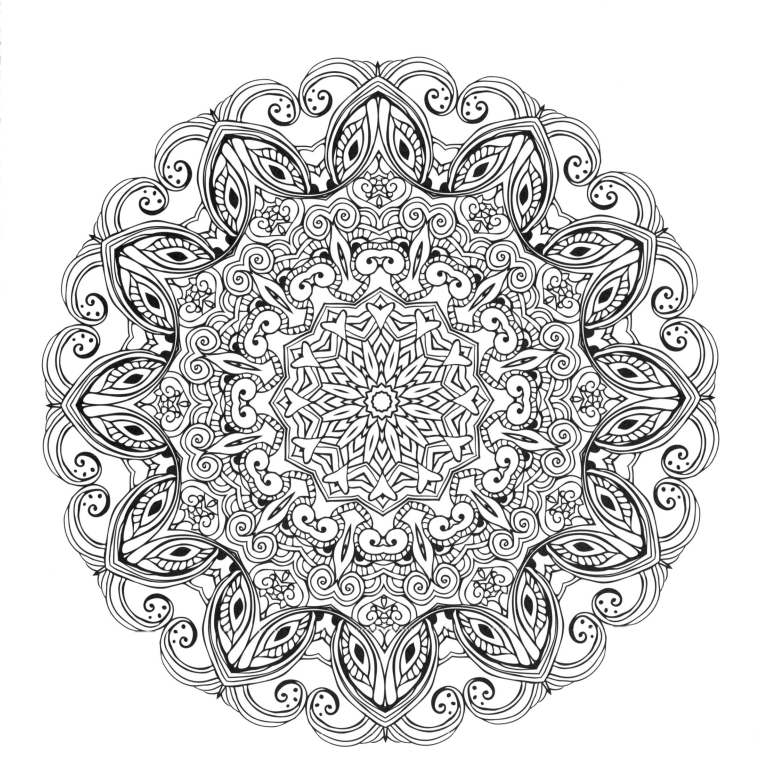

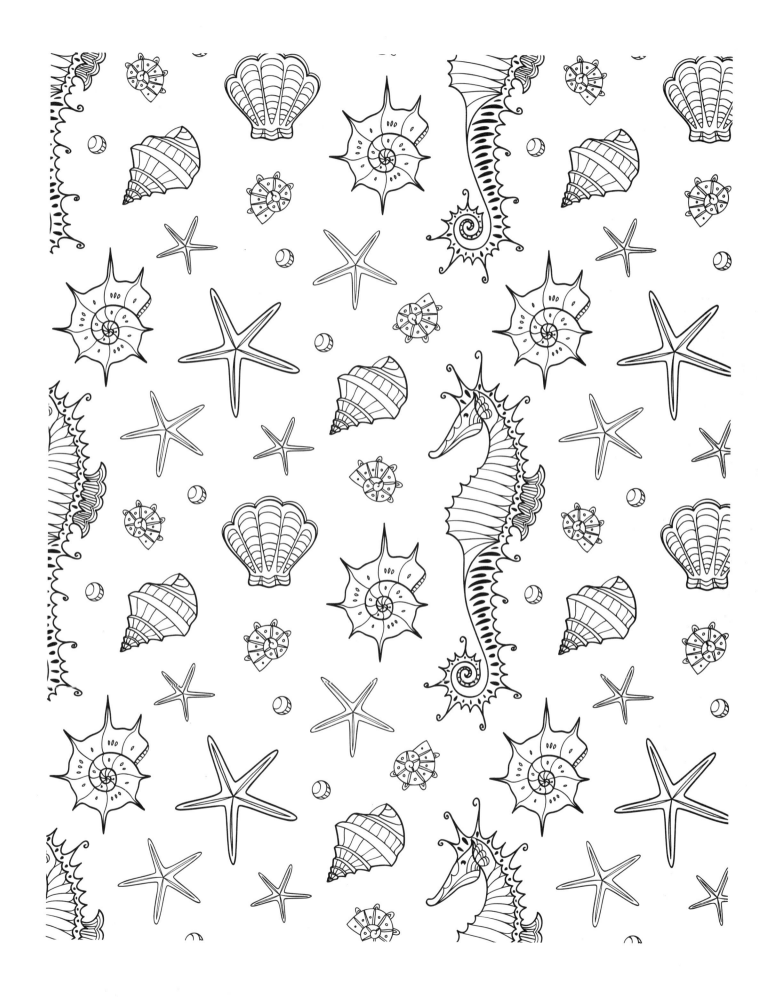

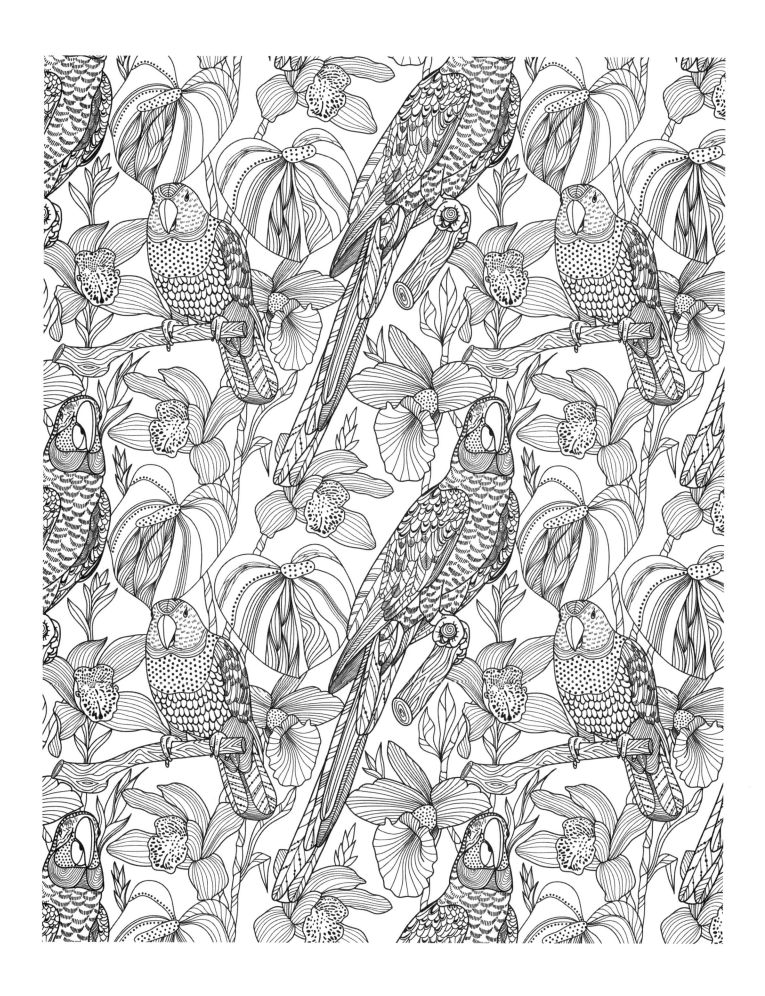